LOVE

LIKE NE'ER BEFORE

Xilla C
Copyright@DrRAVINHUMBARWADI

www.xillaclub.com
Songs Poems
RESHAPE YOUR LIFE

It Always Starts With A Wink

The Thrillin' Autumn Crush

The Day That Made The Night Unforgettable

The Biker

My Life Became a movie Show

Anywhere, Nothin', Anytime

Firing Range

Romance Is A Waltz In D Park

Say Back To Mi

I Want You Coz I Like You

Do not stare at me ... Meow Meow

Moon

It Always Starts With A Wink

Hey you! Hey there
Wink At Me
Winky Winky Wink

Hey you! Hey there
Smile At Me
Smile, Smile, Smiley

Wink At Me A wink
Look, Everyone's lookin'
Let 'em all know
We are Winky Partners
Winky Winky Wink

Smile At Me A Smiley
Look everyone's lookin'
Let 'em all know
We are Smiley Partners
Smile, Smile, Smiley

Let's set the town afire

Blow me a kiss

Blow at me a kiss
Kiss me a kissy
Look everyone's lookin'
Let 'em all know
We are kissy partners…
Kissy Kissy Kiss

Wink At Me A Wink
Smile At Me A Smile
Kiss at me a kiss

Let's set the town afire

It always starts with a wink
Winky, winky, Wink

The Thrillin' Autumn Crush

I got this in My WhatsApp
From A guy I don't Know

Recite (With Feel)

'I reckoned I had
seen it all. Done it all
I imagined like all of us
it was just memories left for us

But then, life is not life
if there was not a twist or a turn

I imagined I had
seen it all, done it all

But then there was
The Autumn crush

The Autumn Crush
Like no other
silent n deep

She looked
She knew
I looked
I knew

Our eyes met n We knew

Instant Silent Deep
Thrilling

The Autumn Crush

She looked Away
Maybe forbidden

I looked away to test her

I looked back to see
She was lookin' back at me

We met again
When our eyes met
We could meet for eternity

The Famed Autumn Crush
It happened to me

Instant Silent Deep
Thrilling
From Now to Eternity'

Yes that woman was me
It happened to me with this
Guy

I'm dressing up to go to
that spot
I want that thrilling Autumn crush
to happen again to me …

The Day That Made The Night Unforgettable

It's The Day I'll Never Forget

You came, stood so near
Were you an apparition?
No..You were the real you

Those were the days I used
to Wait

Just to 'ave a glimpse o' you
You n'er noticed me
Until you did

And then it was a day
like no other

I was on cloud nine
when you began to look a' me

You began to enjoy
My funny crush
You were thrilled
At my funky chase

Then the splendor o' the day
mingled into the romance o' the twilight

N you came to know the love that oozed
That passion I had for
youooooOOOOOOOOOOOOOO

And that day you came
And stood so near

It's the Day That Made The Night
Unforgettable

Were you an apparition?
No ..You were the real you

It's the Day That Made The Night
Unforgettable
The passion I had for
youooooOOOOOOOOOOOOOO

**It's the Day That Made The Night
Unforgettable...**

The Biker

I am that biker
Rugged Muscled n Manly

The one you hav' been waitin' all along
 All alone

The one who came in your dreams
n Made you go weak in d knees

I am that biker
You hav' been waitin' with longin'

The one who came in your feelings
Like you wanted someone just now
Like you wanted someone....just now

The biker on whose bike
you fantasized
A ride

The biker o' your fantasy with whom you went for a
long ride
n never once looked back

The biker o' your dreams
The one who came in your feelings ..
Just like you wanted

The biker
O' your feelings
Just like you felt

My Life Became a movie Show

My life became a movie Show

N I was a movie star

My life became a movie Show

N I was a movie staarr

There was romance all around me

All over again

Yeah Yeah All over Again

Once more One more time

Yeah Yeah All over Again

Still, I didn't flinch

Nor did I think

Coz I loved a woman

N she loved me back!

Still I didn't flinch

Nor did I think

I just allowed love to happen all over again

My life became a movie Show

N I was a movie staarr

Coz I loved a woman

N she loved me back!

Still I didn't flinch

Nor did I think

Coz Love is Blind

I came to know!

Yo Yo Yo! Kno Kno Kno

Yo Yo Yo !

Firing Range

My life became a Movie –Storie
N I found myself facing d firing range

Still I didnt flich
Nor Did I think

Coz I loved a woman n she loved me back

Love Is blind
I came to know

Xtra Xtra
Coz I loved a woman n she loved me back

There was romance all around me
There was romance all over me

My life became a Movie Storie
n I found myself facin' d firing range

Love Is dumb
I came to know
Xtra Xtra

Coz I fell in love wid the wife
N Her husband was a soldier!

My life became a Movie Storie
n I found myself facin' d firing range

Xtra
Xrta Romance Can Be dangerous

Anywhere, Nothin', Anytime

Love can happen anywhere
Love can happen over coffee

Love can happen over nothin'
Coz love is in d air

Love can happen Anytime
Coz Love is always there

Love is an instinct
That never dies

Love is what some live for
Love is what some have died for

Coz love makes us alive like nothin' else can

Say Back To Mi

I will chase you
until you are down and out

Over mountains n valleys
Rivers and Moats

I'll chase you
thru streets and alleys
and walkways and roads

I will chase you
until you are down and out

I will chase you

Until you
Say Back To Mi
I Love U

I Loooveeeee e Youuuuuuuuuuuuu

I will chase you

until you cannot catch your breath

And Breathlessly You
Say Back To Mi
I Love U

I Loooveeeee Youuuuuuuuuuuuu

I will chase you Where Ever you go
Whatever you do

I will chase you

Until you are down and out
Until I can feel your breath on my face
N your lips on my lips
And you say Back to me
While Kissin' me

I Love U

I Loooveeeee Youuuuuuuuuuuuu

I love you.

Romance Is A Waltz In D Park

Romance is just like a waltz in the park
Sometimes a foxtrot
But I prefer the groovy dance number

Romance is just like a waltz in the park
Sometimes a foxtrot
But most times a tango!

When romance becomes a CrossFit
The temperature rises a bit
I am sweatin'
My hearts a beatin'

But there's still time for it

Umm Hmm
There's still time for d gymnast dance
Umm Hmm

As of now let's just take a waltz in d park

What Say Miss?

I Want You Coz I Like You

Boy: I want to see your eyes

I want to feel your vibes

I have a crush on you

Whenever I see you

Ze Ze Ze Ze Look at me now Baby

Look at me now Simmy

Boy: Hi Hi Hi Hi Girl: Bye Bye Bye Bye

Boy: Hi Hi Hi Hi Girl: Bye Bye Bye Bye

Boy: I saw you at the park

I saw you at the club

I saw you in the spa

I saw you at the show

I saw you on the 'scalator

I saw you at the mall

I saw you at the gym

I saw you in the hall

Boy: I feel your charming smile

Far away from a mile

I know you a' liking me

Look at me now Simmy

Boy: Hi Hi Hi Hi Hi Hi Girl: Hi Hi Hi Hi

(The girl said Hi. Whew!)

I want to see your eyes

I want to feel your vibes

Girl: You follow me on Facebook

Like me on Insta

You ping me on Whatsapp

Dial Me Up on Skype

Girl : The game is over now

I wanna feel you close to me

Give me a hug or two

I want you near me Coz I like You very much

I like you verrryyyy much.

Do not stare at me ... Meow Meow

I do what I want
Why the hell you look at me

Why turn back n stare at me
Mind your own cat Meow Meow

Meow Meow

It's not everyday
A girl says Meow Meow

I thought, I was lucky for once
I thought the Meow was meant for me

You thought? You actually did?
When did boys begin to think?

Well it's my lucky day
I met a thinkin' boy
It's my lucky day for sure

Meow Meow For your thoughts

Meow Meow Not for you
Meow Meow Keep on thinkin'boy

Meow Meow I met a thinkin' boy
Meow Meow Mind your own cat

Do not stare at me ... Meow Meow

Moon Is Full – Just Like My Love

The Moon is full today
Just like my love

It waxes and wanes
riplles and waves

I'm afraid
It may not be the same

Come love me like you never do

Hold me tight
like I always wanted you to

Today the moon is full
Just like my love

So bright and beautiful
So near So live
Look there the moon is full
Just like my love I feel for you

Come love me like you never did
Hold me tight
Never let me go

Let the moon go
It waxes and wanes
Ripples an waves

Let my love be full
So bright n beautiful
For as long as I live

Come love me like you never do
Come love me like you never did

Hold me tight
Hold me all around
To Never let me go

North Korea ... Best Friends

North Korea, North Koreans
I saw the parade
The shrieks of the soldiers
The cutes of the planet
The men so smart and so the ladies
Ah! If I were to be killed in a war
Let it be by a Korean soldier.

Let's stop playin' boys
If u sock me I will sock you harder
Ha haha
 If you touch me
I will break your nostril
Ha ha

Nuclear missiles are not toys
We all fit in a world order

Let us all be world leaders
Help the Africans with their hunger
Millions starve

The glaciers are meltin'
The heat is rising
Solve the climate problem

Maybe while you are at it
Help the Americans with jobs
They are losing them too may
Huh !

So there the world is waitin'
With bated breath

North Korea Where are you
When we need you

North Korea We love you like we do the South

North Korea you are part of the world
Part of us
If we do need to die
Let us all die together

But then till such a time comes
 Come Lets be friends
Coz boys will be boys
And If you still remember
Boys can be the best of friends!

Vroom Vroom
I'm goin' to go and Ne'er look back
Vroom Vroom
I'm going to go and Ne'er come back

He's givin' me love
N he's givin' me a ride
He's givin' me power
N he's givin' me pride
My fantasy biker has come 'live

Vroom Vroom
I'm goin' to go and Ne'er look back
Vroom Vroom
I'm going to go and Ne'er come back

It Always Starts With A Wink

The Thrillin' Autumn Crush

The Day That Made The Night Unforgettable

The Biker

My Life Became a movie Show

Anywhere, Nothin', Anytime

Firing Range

Romance Is A Waltz In D Park

Say Back To Mi

I Want You Coz I Like You

Do not stare at me ... Meow Meow

MOON Is Full
Just Like My Love

www.xillaclub.com

Reshape Your Life.

www.ingramcontent.com/pod-product-compliance
Lightning Source LLC
Chambersburg PA
CBHW030548220526
45463CB00007B/3022